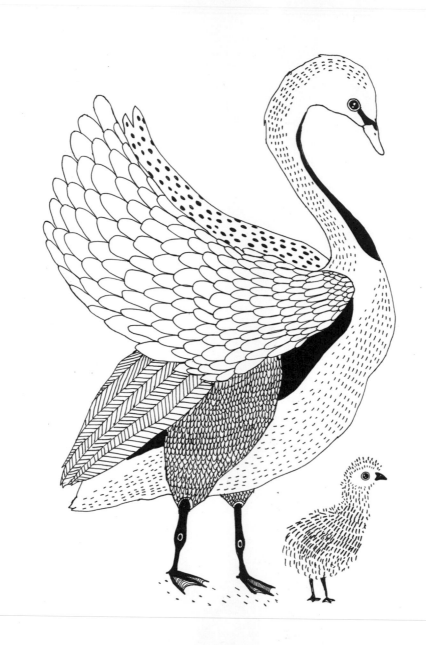

animals

—— OF A ——

BYGONE
ERA

an illustrated
COMPENDIUM

MAJA SÄFSTRÖM

TEN SPEED PRESS
CALIFORNIA | NEW YORK

DINOSAURS
HAVE INTENTIONALLY
BEEN LEFT OUT OF
THIS BOOK
TO GIVE SOME
ATTENTION TO
OTHER FASCINATING
— BUT LESS FAMOUS —
CREATURES THAT
ONCE LIVED ON
THIS PLANET.

WAIT,
WHAT?!

7. INTRODUCTION

9. DICKINSONIA COSTATA
11. HALLUCIGENIA
13. HAIKOUICHTHYS
15. OPABINIA
17. CAMEROCERAS
19. PTERASPIS
21. GIANT SEA SCORPION
23. DUNKLEOSTEUS TERRELLI
25. MEGANEURA
27. HELICOPRION
29. DIMETRODON
31. SHAROVIPTERYX
33. GERROTHORAX
35. OPHTHALMOSAURUS

37. ELASMOSAURUS
39. QUETZALCOATLUS
41. TERROR BIRD
43. TITANOBOA
45. CORYPHODON
47. DAWN HORSE
49. DIACODEXIS
51. LEPTICTIDIUM
53. WALKING WHALE
55. EOMANIS
57. GIANT GROUND SLOTH
59. BASILOSAURUS
61. EMBOLOTHERIUM
63. INDRICOTHERIUM

65. CARCHAROCLES MEGALODON

67. MOA

69. PLATYBELODON

71. CHALICOTHERIUM

73. HORNED GOPHER

75. SYNTHETOCERAS

77. GIANT ASIAN APE

79. MACRAUCHENIA

81. SHIVA'S BEAST

83. WALRUS WHALE

85. NURALAGUS REX

87. GIANT PACARANA

89. IRISH ELK

91. GIANT SIBERIAN UNICORN

93. WOOLLY MAMMOTH

95. CAVE BEAR

97. DOEDICURUS

99. SABER-TOOTHED CAT

101. GIANT SWAN

103. GIANT SHORT-FACED KANGAROO

105. TASMANIAN TIGER

107. DODO BIRD

109. SADDLE-BACKED RODRIGUES GIANT TORTOISE

110. ACKNOWLEDGMENTS

111. ABOUT THE AUTHOR

DEAR READER,

IN THIS BOOK I HAVE
ILLUSTRATED AND PRESENTED
A FEW OF THE COUNTLESS
AMAZING CREATURES
THAT ONCE ROAMED
THE EARTH.

SOME OF THEM LIVED
A LONG TIME AGO,
WHILE OTHERS LIVED UNTIL
VERY RECENTLY.

I HOPE THAT YOU
ENJOY THE BOOK,
LEARN SOMETHING NEW,
AND ARE REMINDED OF THE
BEAUTIFUL, COMPLEX,
AND DELICATE HISTORY
OF THIS WORLD.

THE
DICKINSONIA
COSTATA
WAS A VERY
PRIMITIVE WATER
CREATURE.

EUROPE & AUSTRALIA
560-555
MILLION
YEARS AGO

HEAD

YOUNG

OLD AND
BIG AS A PERSON
(BUT FLAT AS A PANCAKE!)

THEY
HAD NO
KNOWN MAXIMUM
SIZE; THEY JUST
GREW UNTIL
THEY DIED!!

THEY HAD
NO MOUTHS.
INSTEAD THEY
ABSORBED NUTRIENTS
WITH THEIR BELLIES!

9.

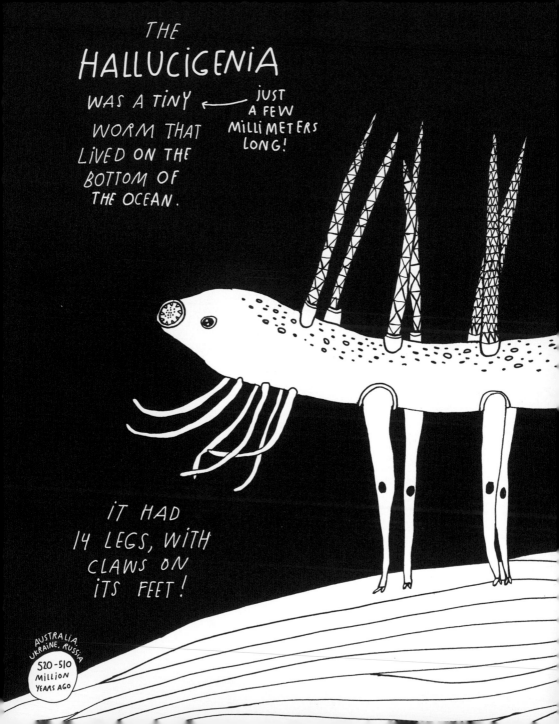

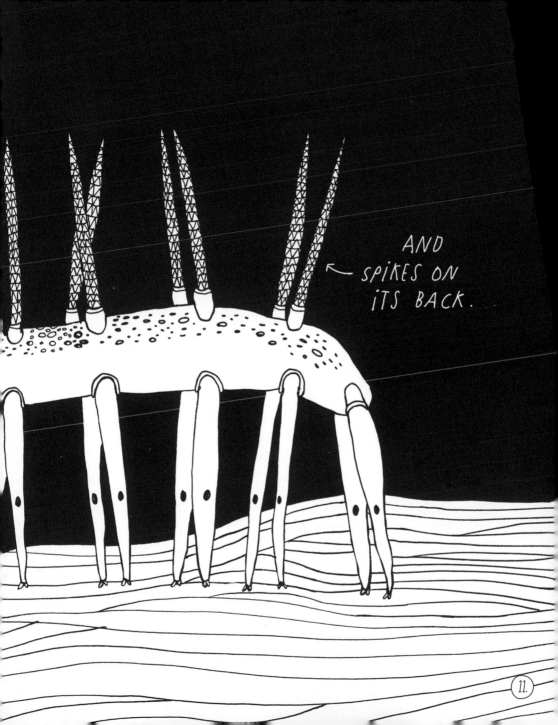

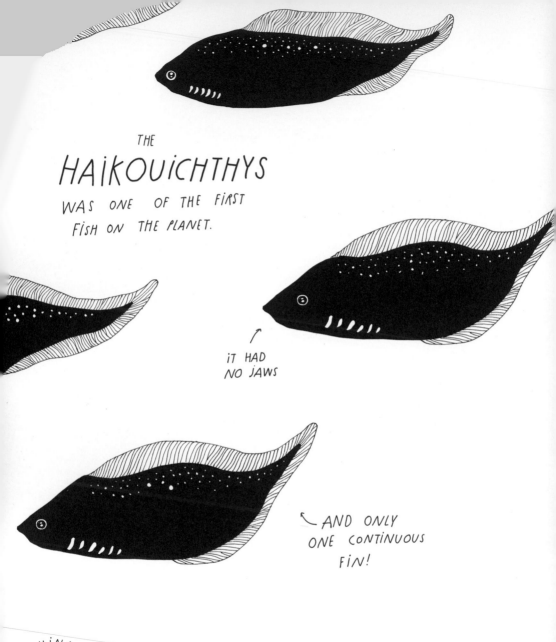

THE

HAIKOUICHTHYS

WAS ONE OF THE FIRST
FISH ON THE PLANET.

iT HAD
NO JAWS

AND ONLY
ONE CONTINUOUS
FIN!

CHINA

520-516
MILLION
YEARS AGO

AND
IT WAS AS
BIG
AS A THUMB.

ACTUAL SIZE

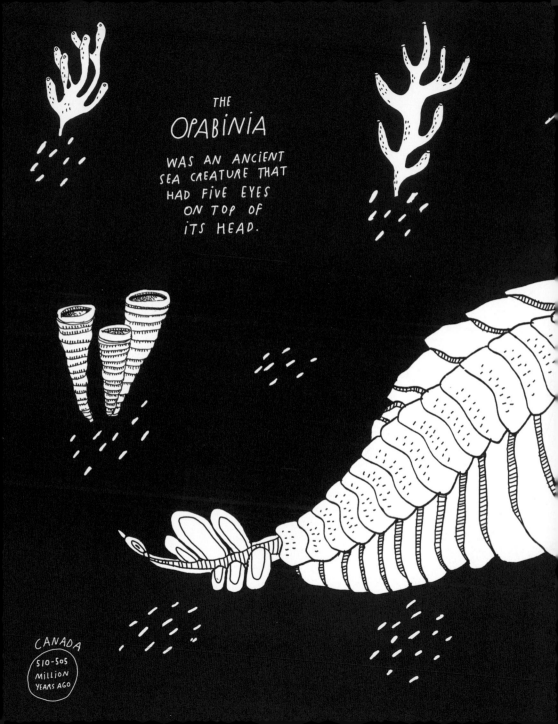

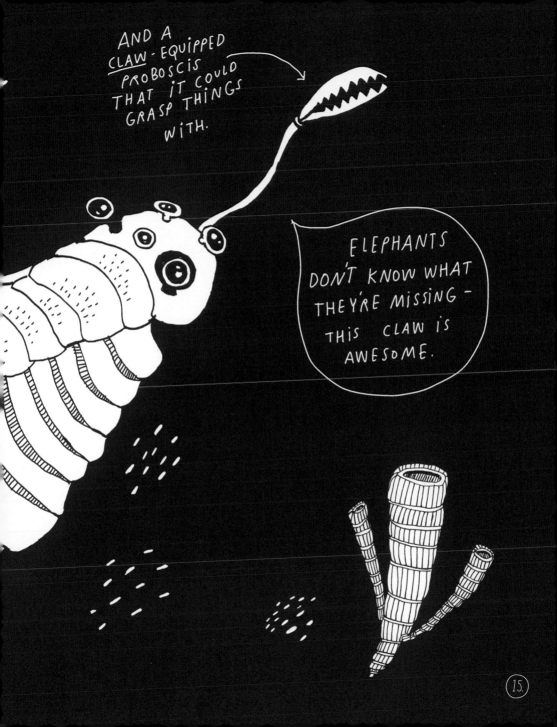

THE **CAMEROCERAS** WAS AN EARLY OCTOPUS RELATIVE WITH RIDGES ON ITS TENTACLES INSTEAD OF SUCTION CUPS.

EUROPE, CHINA, NORTH AMERICA

470-425 MILLION YEARS AGO

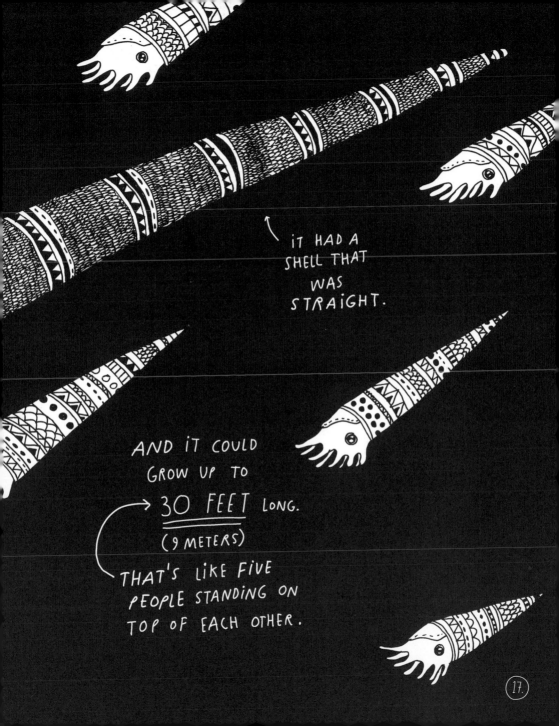

IT HAD A
SHELL THAT
WAS
STRAIGHT.

AND IT COULD
GROW UP TO

30 FEET LONG.
(9 METERS)

THAT'S LIKE FIVE
PEOPLE STANDING ON
TOP OF EACH OTHER.

17.

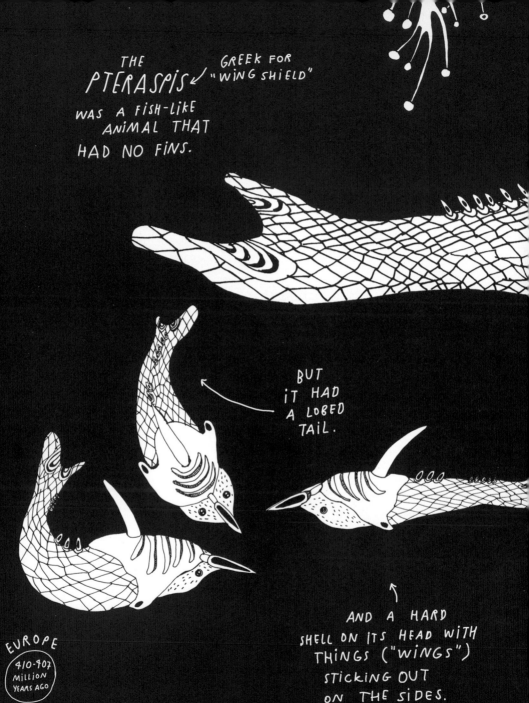

THE **PTERASPIS** GREEK FOR "WING SHIELD"
WAS A FISH-LIKE ANIMAL THAT HAD NO FINS.

BUT iT HAD A LOBED TAIL.

AND A HARD SHELL ON ITS HEAD WITH THINGS ("WINGS") STICKING OUT ON THE SIDES.

EUROPE
410-407 MILLION YEARS AGO

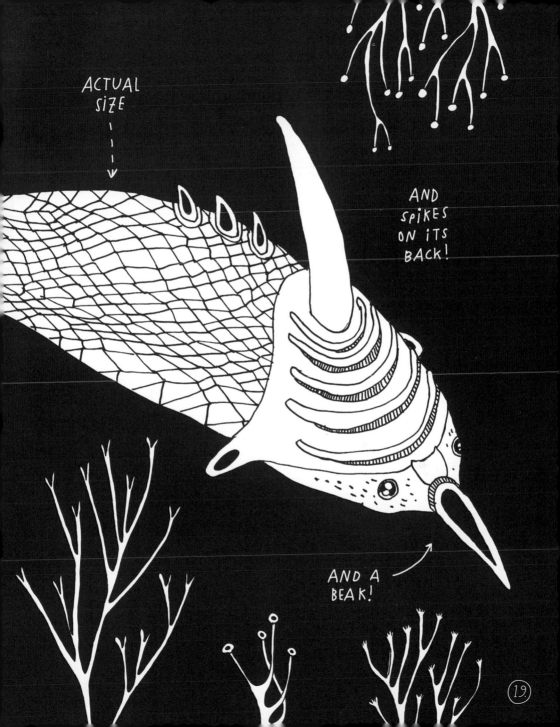

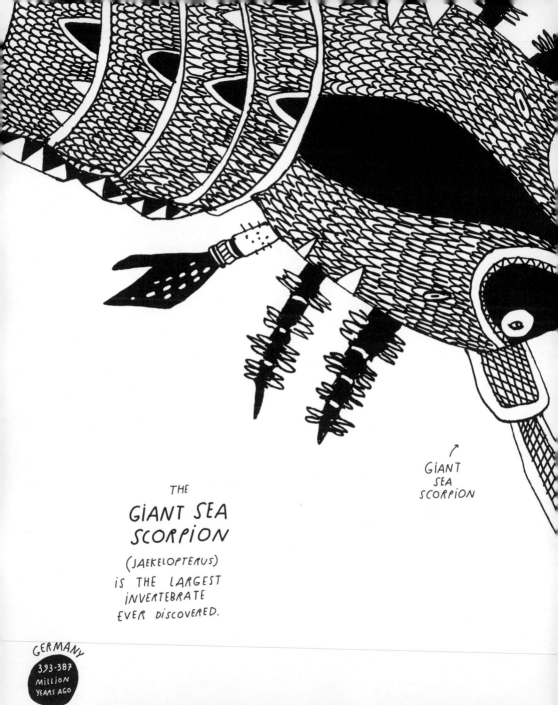

THE

GIANT SEA
SCORPION

(JAEKELOPTERUS)

IS THE LARGEST
INVERTEBRATE
EVER DISCOVERED.

GIANT
SEA
SCORPION

GERMANY
393-387
MILLION
YEARS AGO

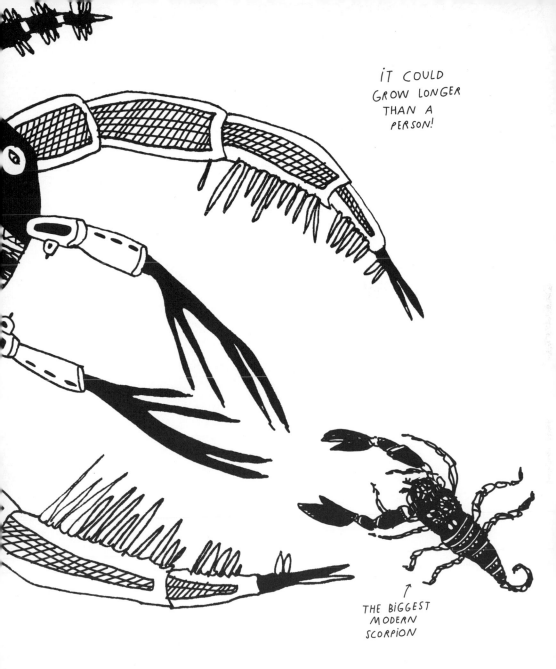

IT COULD GROW LONGER THAN A PERSON!

THE BIGGEST MODERN SCORPION

21.

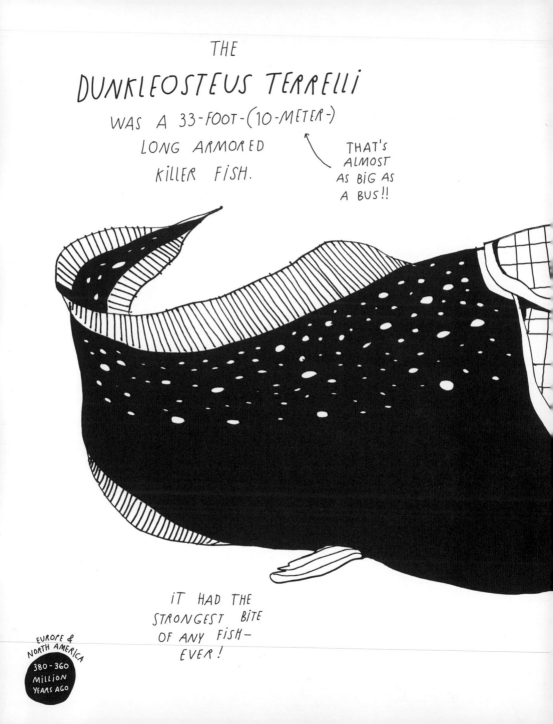

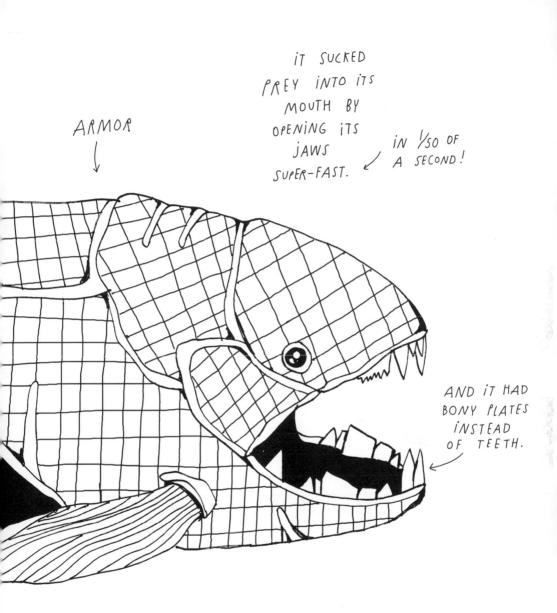

ARMOR

IT SUCKED PREY INTO ITS MOUTH BY OPENING ITS JAWS SUPER-FAST.

IN 1/50 OF A SECOND!

AND IT HAD BONY PLATES INSTEAD OF TEETH.

23.

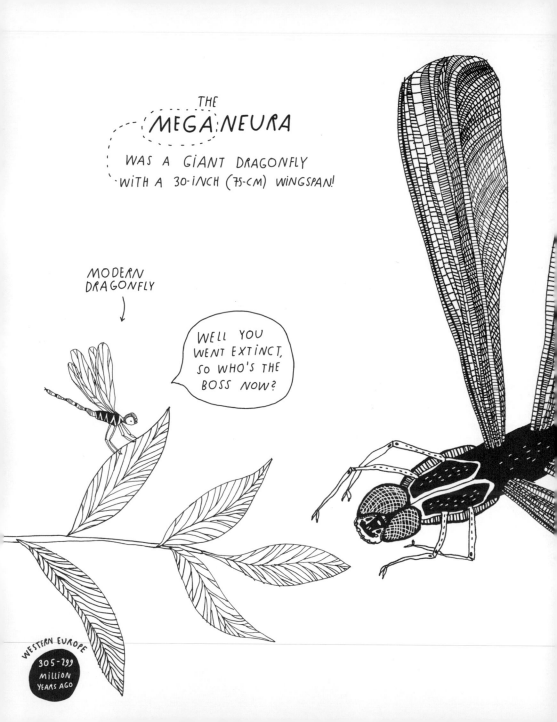

ALL THAT REMAINS
OF THE

HELICOPRION,

A SHARK-LIKE CREATURE,

ARE MYSTERIOUS
SPIRAL-SHAPED
FOSSILS.

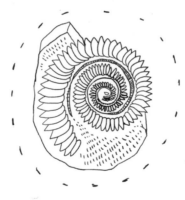

MYSTERIOUS
SPIRAL-SHAPED
FOSSIL.

THEIR TRUE
ANATOMY HAS
BEEN SUBJECT TO
COUNTLESS
(AND OFTEN ELABORATE)
RECONSTRUCTION
ATTEMPTS.

THE WHOLE WORLD

290-250
MILLION
YEARS AGO

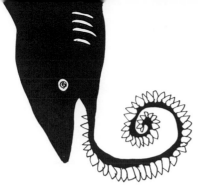

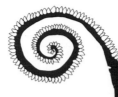

THE LATEST
THEORY IS THAT
THE SPIRAL
CONTAINED SOME
150 TEETH
THAT GREW
OUT OF THE
LOWER JAW.

NAILED
IT.

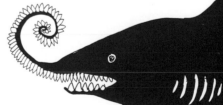

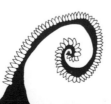

THE

DIMETRODON

WAS THE SIZE OF
A MODERN CROCODILE
AND HAD A HUGE
MYSTERIOUS SAIL
ON ITS BACK.

IT IS OFTEN
WRONGLY THOUGHT
TO BE A DINOSAUR
WHEN IT ACTUALLY
WENT EXTINCT
<u>40 MILLION</u> YEARS
BEFORE THE FIRST
DINOSAURS!

NORTH AMERICA
290-272
MILLION
YEARS AGO

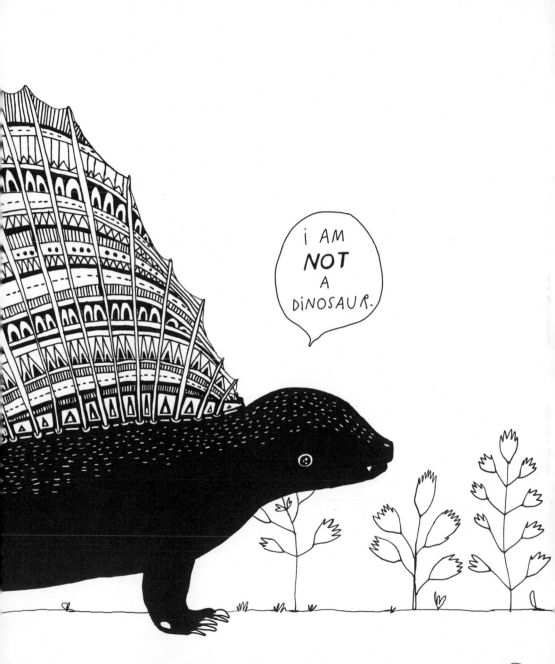

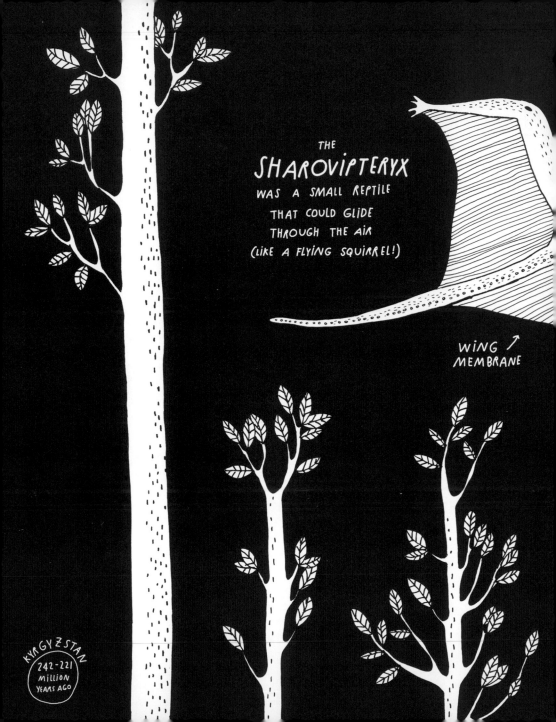

THE **SHAROVIPTERYX** WAS A SMALL REPTILE THAT COULD GLIDE THROUGH THE AIR (LIKE A FLYING SQUIRREL!)

WING → MEMBRANE

KYRGYZSTAN
242-221 MILLION YEARS AGO

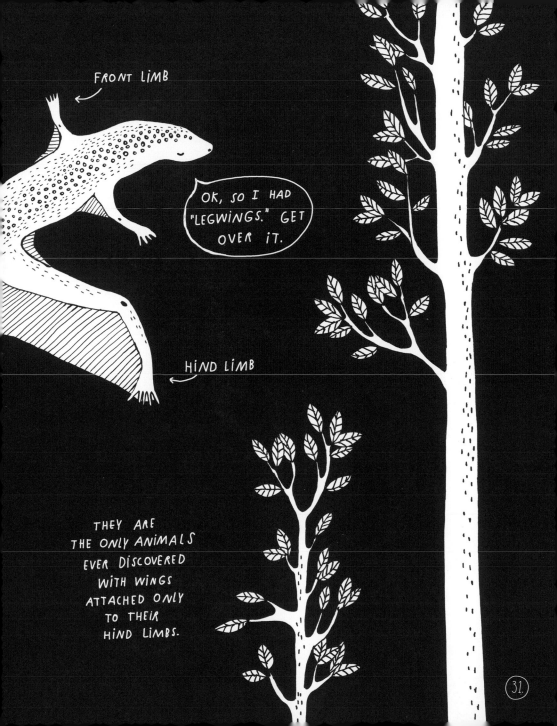

THE
GERROTHORAX
WAS ONE OF THE
FIRST CREATURES
TO COME OUT OF THE
WATER.

IT HAD "LEGS"
BUT IT COULD
NOT WALK WITH
THEM — JUST SWIM
OR CRAWL...

EUROPE
235-201
MILLION
YEARS AGO

IT HAD A METER-LONG,
SUPERFLAT BODY.

SO FLAT,
BOTH EYES
WERE PLACED ON TOP
OF ITS HEAD.

WHEN OPENING
ITS MOUTH, IT LIFTED ITS HEAD
WITHOUT DROPPING ITS JAW—

JUST LIKE A TOILET SEAT!

THE

OPHTHALMOSAURUS

WAS A 19-FOOT-LONG ← (6 METERS)
MARINE REPTILE WITH
EYES THE SIZE OF

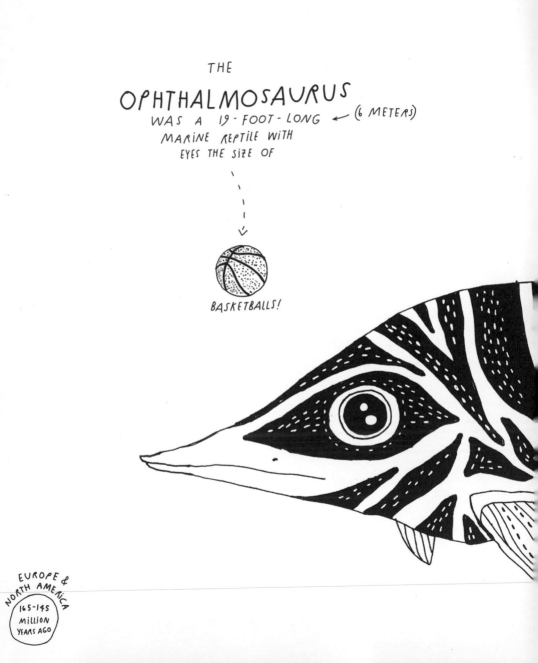

BASKETBALLS!

FOSSILS SHOW
THAT THEY
GAVE BIRTH
TO LIVE YOUNG.

SINCE THEY
COULD NOT
BREATHE UNDER
WATER, THE BABIES
WERE BORN
TAIL FIRST—

SO THAT
THEY WOULDN'T
DROWN!

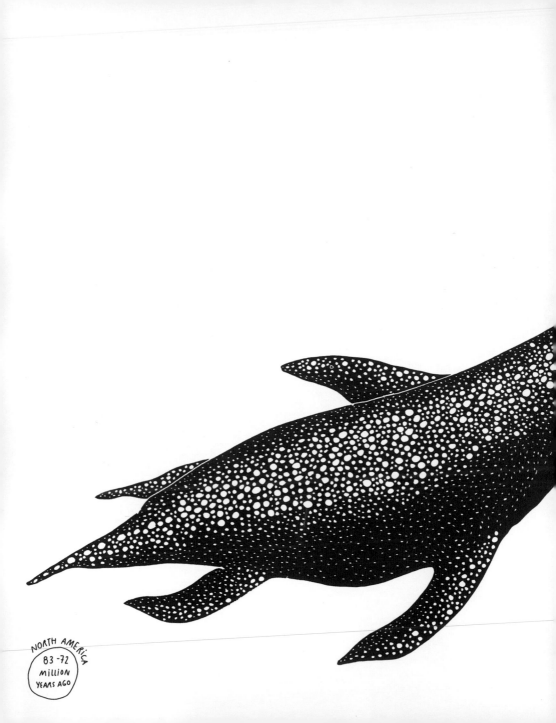

NORTH AMERICA
83-72
MILLION
YEARS AGO

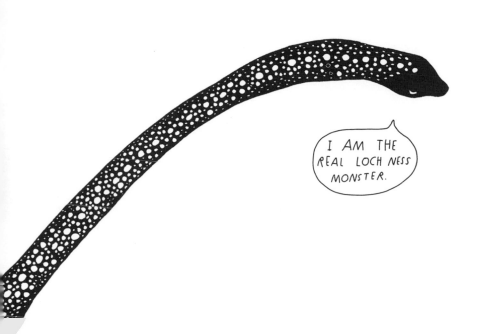

THE
ELASMOSAURUS
WAS A
42-FOOT-(13-METER-) LONG
SEA CREATURE WITH
AN IMPRESSIVELY
LONG NECK.

THE
QUETZALCOATLUS
WAS THE LARGEST
FLYING* ANIMAL OF
ALL TIME
(IT HAD THREE TIMES
THE WINGSPAN OF
AN ALBATROSS).

ITS WINGS
WERE COVERED
BY A LEATHERY
MEMBRANE. →

NORTH AMERICA
72-66
MILLION
YEARS AGO

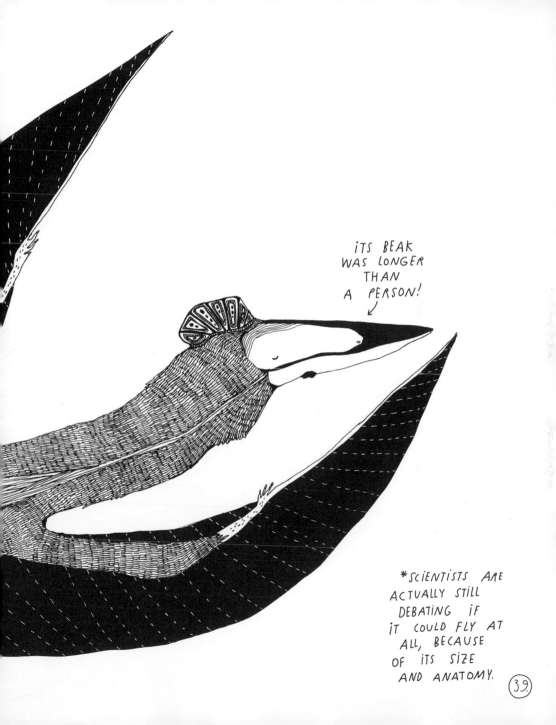

TERROR BIRDS

(PHORUSRHACOS)

WERE ONCE THE
LARGEST PREDATORS
IN SOUTH AMERICA.
(THEY WERE
TALLER THAN
A PERSON!)

NORTH & SOUTH
AMERICA
62-1,8
MILLION
YEARS AGO

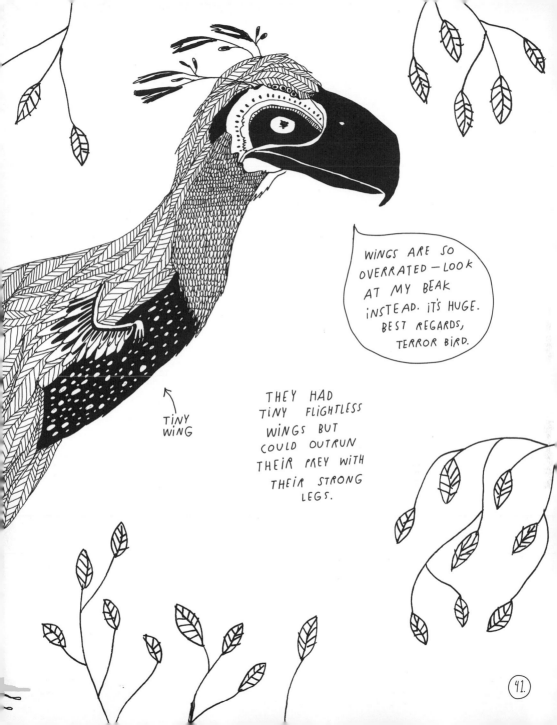

THE
TITANOBOA
WAS THE BIGGEST
SNAKE OF ALL TIME.

THEY
MOST LIKELY
FED ON
CROCODILES!

COLOMBIA
60-58
MILLION
YEARS AGO

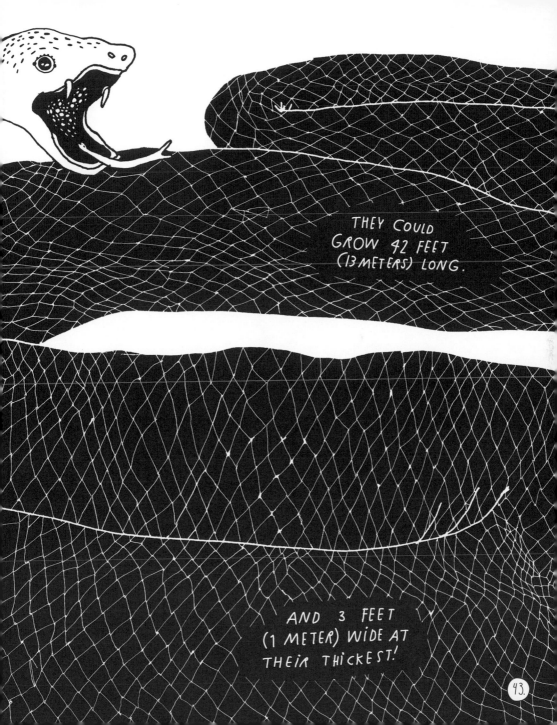

THEY COULD
GROW 42 FEET
(13 METERS) LONG.

AND 3 FEET
(1 METER) WIDE AT
THEIR THICKEST!

THE

CORYPHODON
is FAMOUS FOR
HAVING THE SMALLEST
BRAIN-TO-BODY RATIO
OF ANY MAMMAL THAT
HAS EVER LIVED!

SiZE OF
A SMALL
HiPPO

ASiA, EUROPE,
NORTH AMERICA

56-46
MiLLION
YEARS AGO

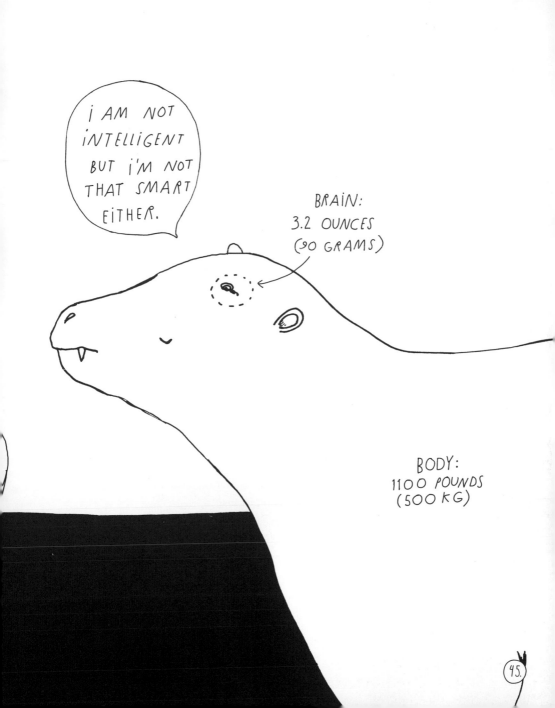

MODERN
HORSE →

THE
DAWN HORSE
(HYRACOTHERIUM)
is one of the first known ancestors of modern horses!

DAWN HORSE

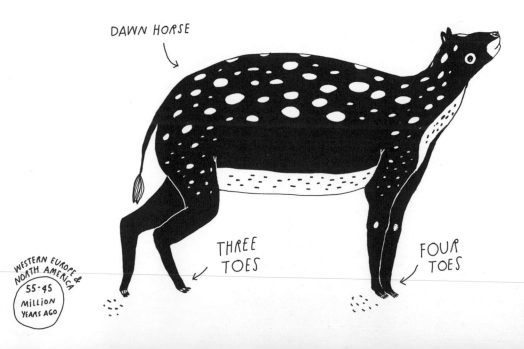

THREE TOES

FOUR TOES

WESTERN EUROPE &
NORTH AMERICA
55-45
MILLION
YEARS AGO

IT
WAS TINY
(THE SIZE OF A DOG)
AND HAD
TOES INSTEAD
OF HOOVES.

A HOOF

47.

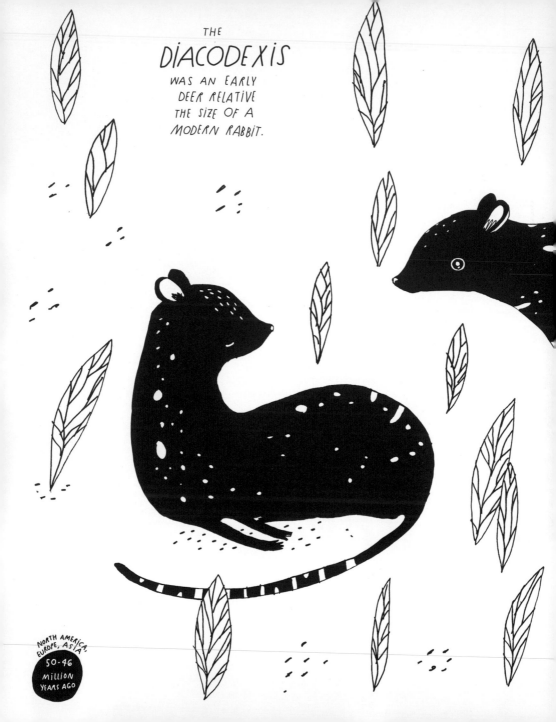

THE
DIACODEXIS
WAS AN EARLY
DEER RELATIVE
THE SIZE OF A
MODERN RABBIT.

NORTH AMERICA,
EUROPE, ASIA

50-46
MILLION
YEARS AGO

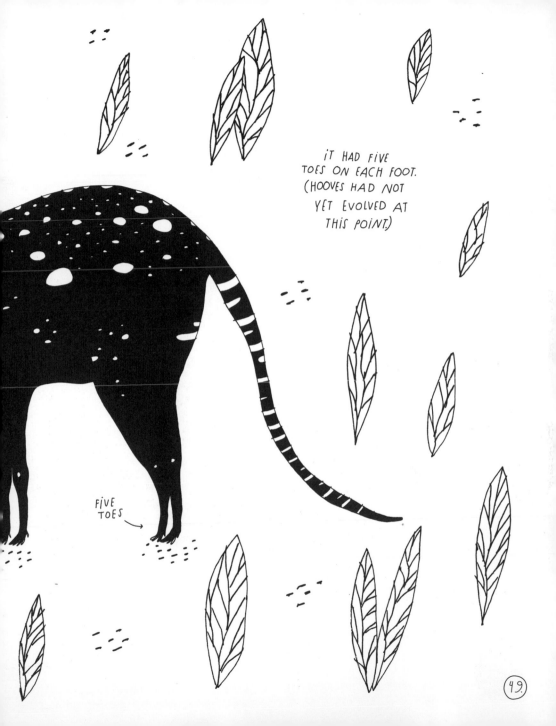

IT HAD FIVE
TOES ON EACH FOOT.
(HOOVES HAD NOT
YET EVOLVED AT
THIS POINT.)

FIVE
TOES →

49.

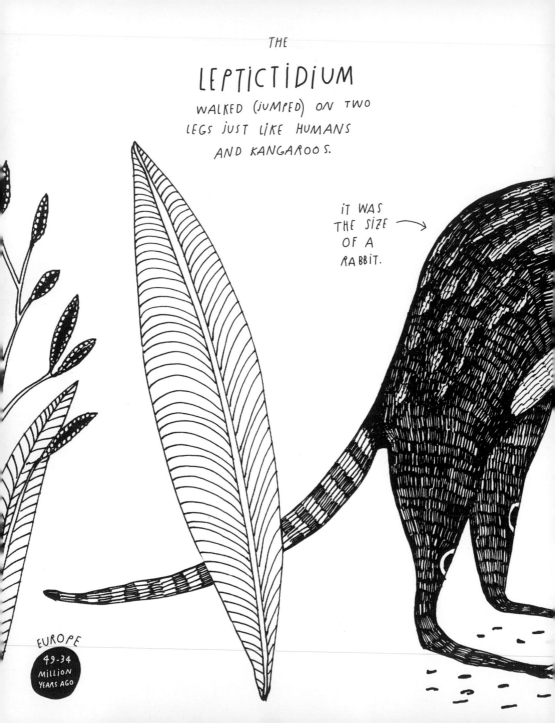

THE

LEPTICTIDIUM

WALKED (JUMPED) ON TWO
LEGS JUST LIKE HUMANS
AND KANGAROOS.

IT WAS
THE SIZE
OF A
RABBIT. →

EUROPE
49-34
MILLION
YEARS AGO

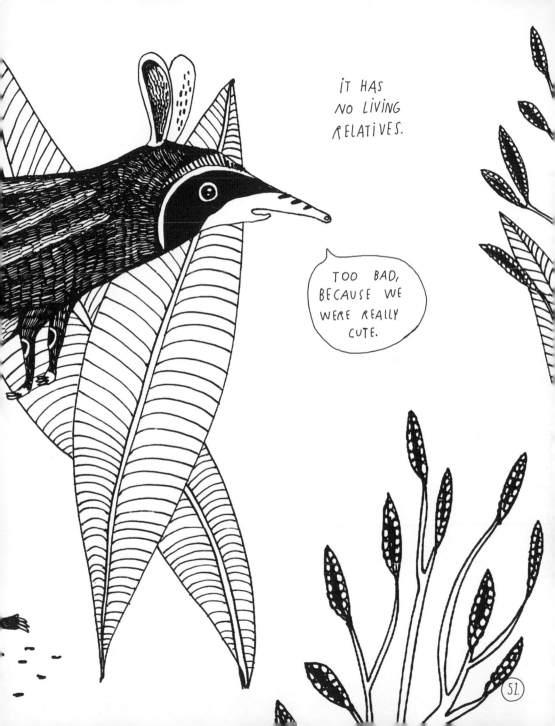

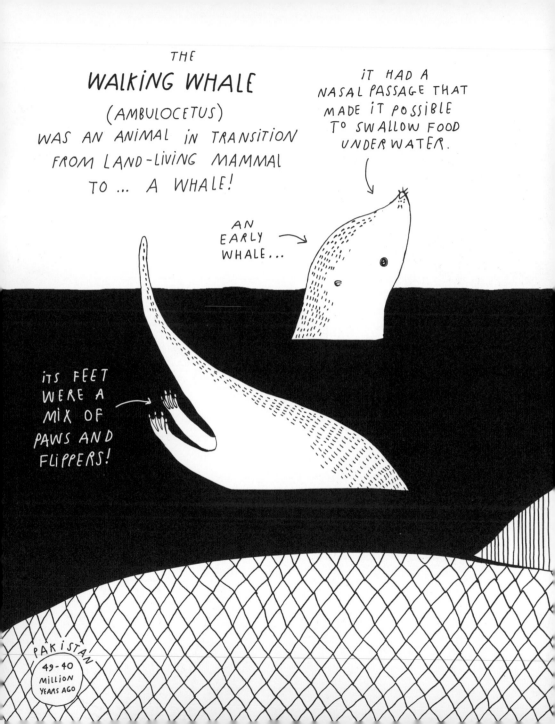

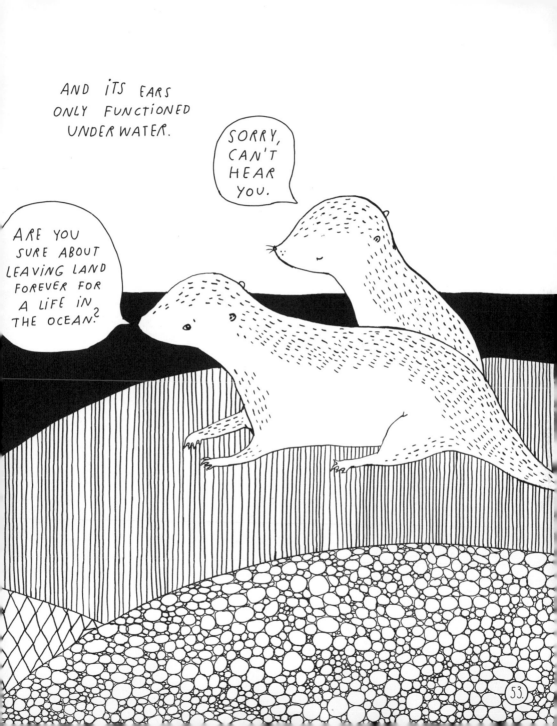

THE
EOMANIS

WAS THE FIRST PANGOLIN.
IT LOOKED SIMILAR TO ITS
MODERN RELATIVES BUT
HAD NO SCALES ON ITS
LEGS OR TAIL.

NO SCALES

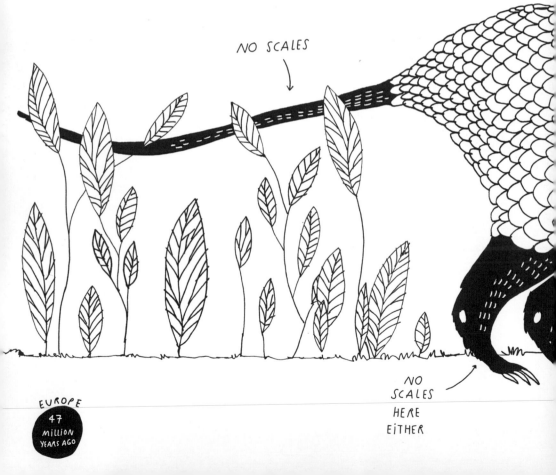

NO
SCALES
HERE
EITHER

EUROPE
47
MILLION
YEARS AGO

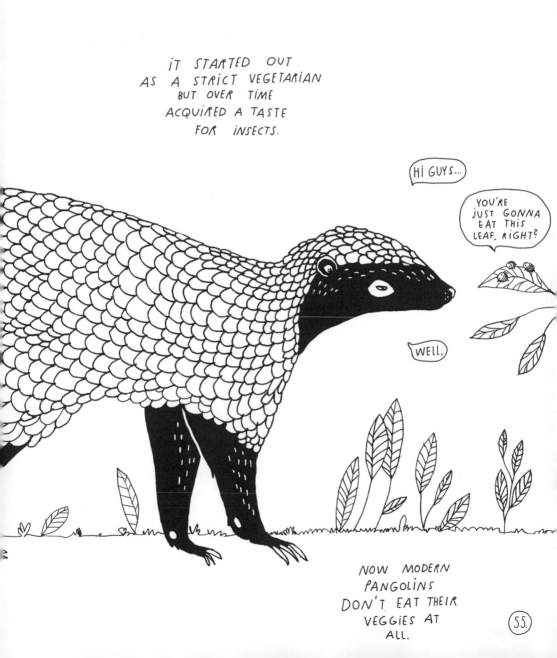

GIANT GROUND SLOTHS
(MEGATHERIUM)
WERE UP TO 22 FEET TALL!
(7 METERS)

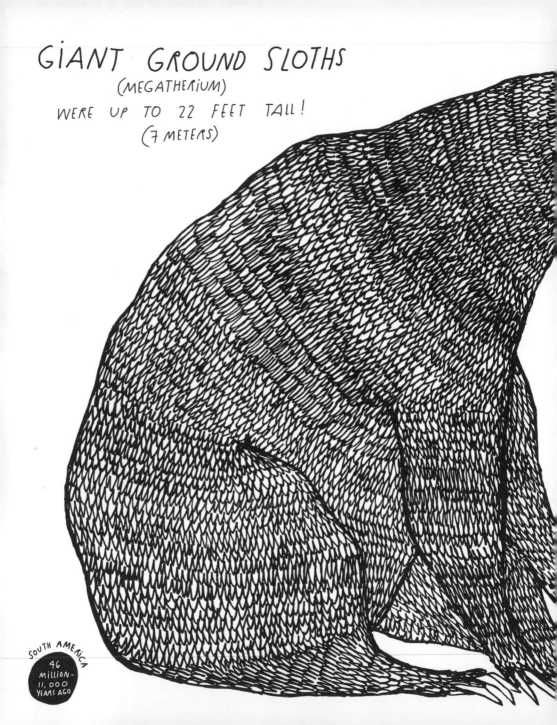

SOUTH AMERICA
46 MILLION - 11,000 YEARS AGO

INSTEAD OF
CLIMBING
LIKE TODAY'S
SLOTHS,
THEY COULD
REACH BRANCHES
IN THE TOP
OF THE TREES BY
STANDING ON
TWO LEGS
ON THE GROUND.

THE
BASILOSAURUS
WAS AN EARLY
EEL-SHAPED
WHALE.

THEY COULD GROW
65 FEET LONG!
(20 METERS)
↓

NORTH AFRICA
& NORTH AMERICA
40-34
MILLION
YEARS AGO

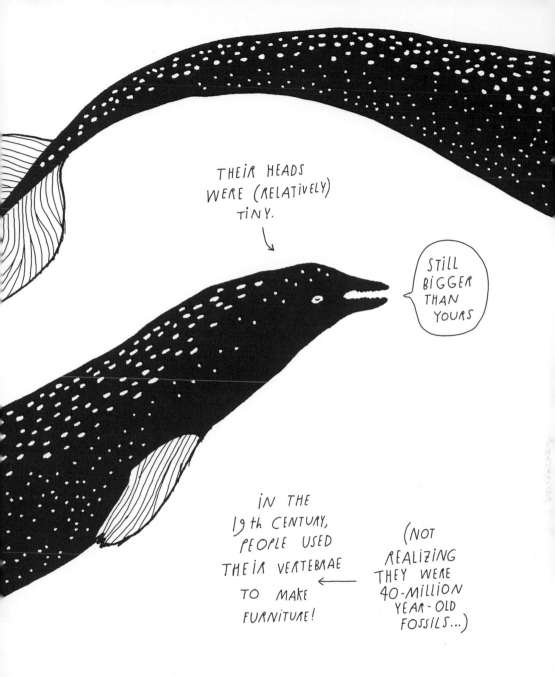

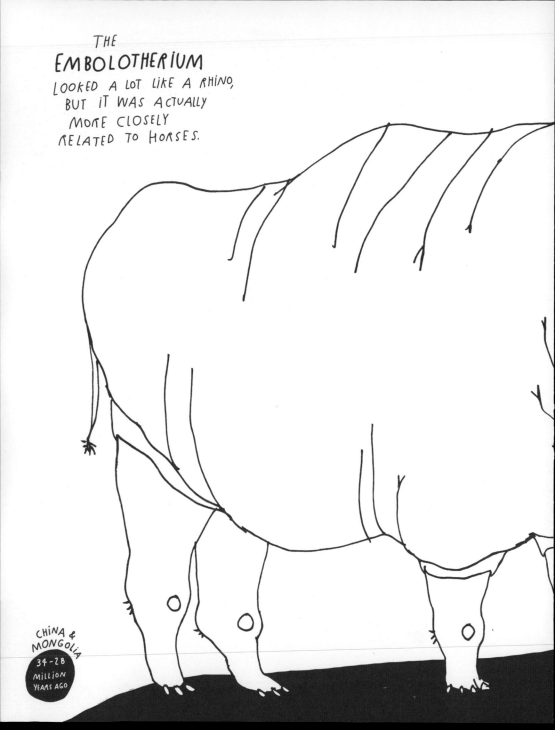

THE
EMBOLOTHERiUM
LOOKED A LOT LIKE A RHINO,
BUT iT WAS ACTUALLY
MORE CLOSELY
RELATED TO HORSES.

CHiNA &
MONGOLiA
34-28
MiLLiON
YEARS AGO

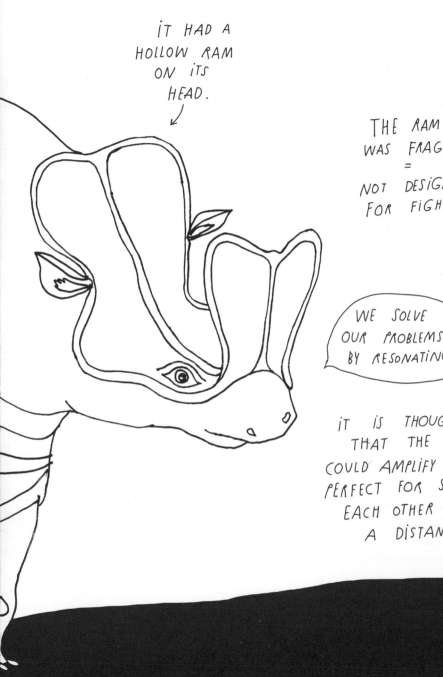

THE

INDRICOTHERIUM

WAS A HORNLESS
RHINO AND
ONE OF THE
BIGGEST LAND MAMMALS
OF ALL TIME!

CHINA & EUROPE
34-23
MILLION
YEARS AGO

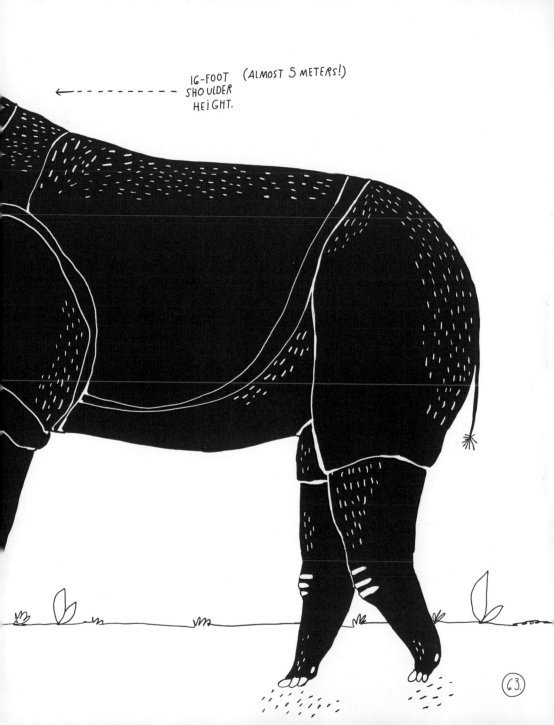

16-FOOT (ALMOST 5 METERS!)
SHOULDER
HEIGHT.

63.

THE
CARCHAROCLES
MEGALODON
WAS THE BIGGEST
SHARK THAT EVER LIVED.

iTS TEETH
WERE EACH AS
BiG AS A
HUMAN HAND!

THE
WHOLE · WORLD
25 - 1.5
MiLLioN
YEARS AGO

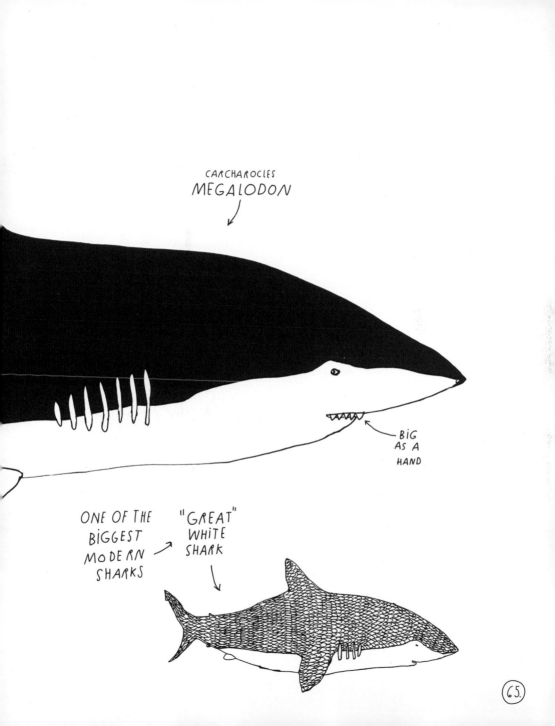

CARCHAROCLES
MEGALODON

BIG
AS A
HAND

ONE OF THE
BIGGEST
MODERN
SHARKS

"GREAT"
WHITE
SHARK

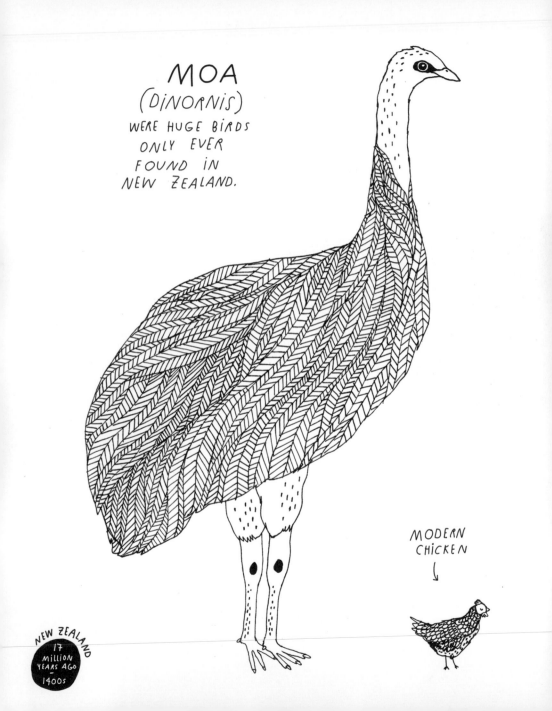

MOA
(DINORNIS)

WERE HUGE BIRDS
ONLY EVER
FOUND IN
NEW ZEALAND.

MODERN
CHICKEN

NEW ZEALAND
17
MILLION
YEARS AGO
–
1400s

THEY ARE
THE ONLY
BIRDS KNOWN
TO BE COMPLETELY
WITHOUT WINGS.

UNFORTUNATELY,
THEIR FRIENDLY
MANNERS MADE
THEM EASY TARGETS
FOR HUMANS,
AND THEY
WENT EXTINCT
BY 1445.

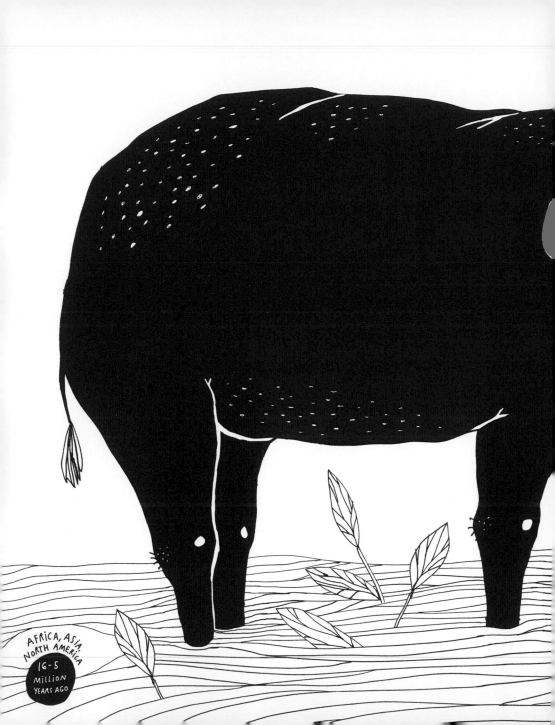

AFRICA, ASIA
NORTH AMERICA

16-5
MILLION
YEARS AGO

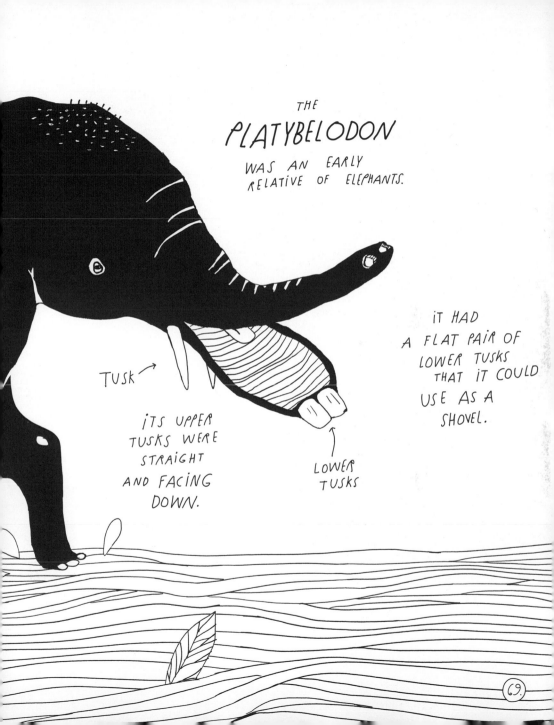

THE
PLATYBELODON
WAS AN EARLY
RELATIVE OF ELEPHANTS.

IT HAD
A FLAT PAIR OF
LOWER TUSKS
THAT IT COULD
USE AS A
SHOVEL.

TUSK →

ITS UPPER
TUSKS WERE
STRAIGHT
AND FACING
DOWN.

LOWER
TUSKS

THE
CHALICOTHERIUM
WAS AN ANCIENT MAMMAL
THE SIZE OF A MODERN ELEPHANT
THAT LOOKED LIKE A CROSS
BETWEEN A HORSE
AND A GORILLA!

THEY
MOVED
ON THEIR
KNUCKLES
LIKE GORILLAS.

AFRICA, EUROPE, ASIA,
NORTH AMERICA

15 - 7
MILLION
YEARS AGO

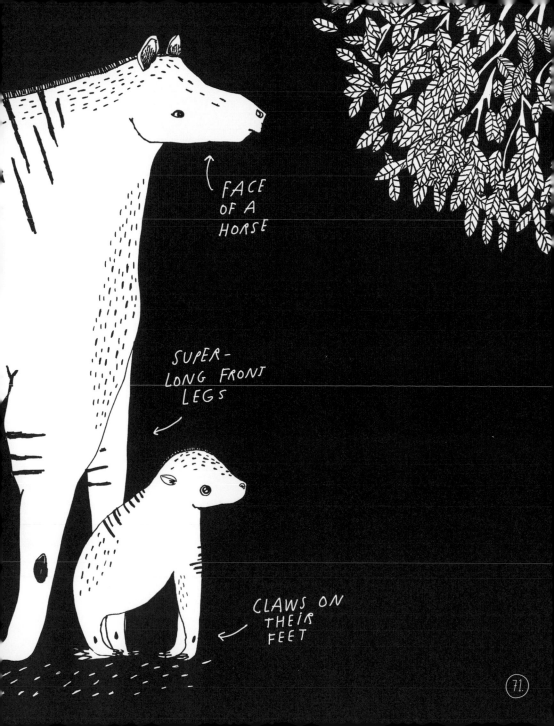

FACE OF A HORSE

SUPER-LONG FRONT LEGS

CLAWS ON THEIR FEET

HORNED GOPHERS
(CERATOGAULUS)

WERE MARMOT-LIKE BURROWING
ANIMALS THAT HAD HORNS
ON TOP OF THEIR HEADS!

THEY ARE THE ONLY
KNOWN RODENTS
WITH HORNS
IN HISTORY!

NORTH AMERICA
14-5.3
MILLION
YEARS AGO

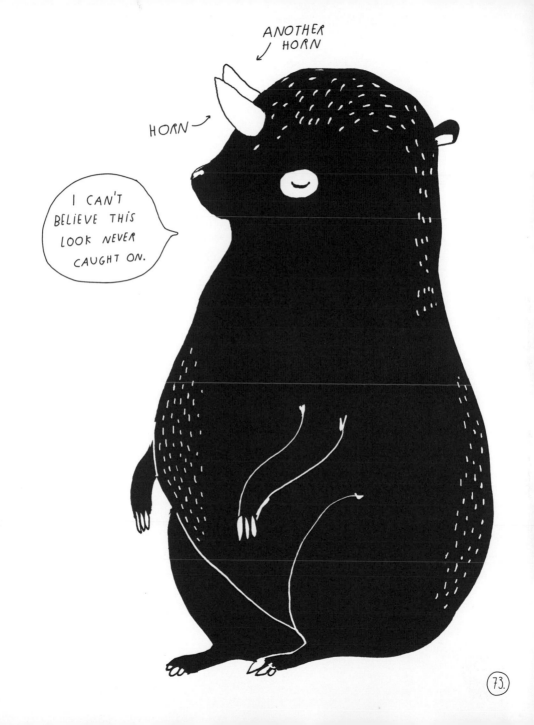

THE SYNTHETOCERAS

LOOKED A LOT LIKE A MODERN DEER.

I'D PREFER "UNICORN," THANKS.

BUT THE MALES HAD ONE LONG FORKED HORN ON THEIR SNOUTS!

NORTH AMERICA
10 - 5.3 MILLION YEARS AGO

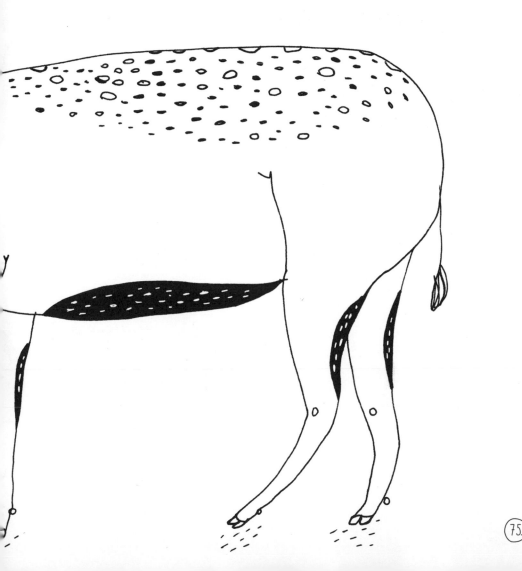

y

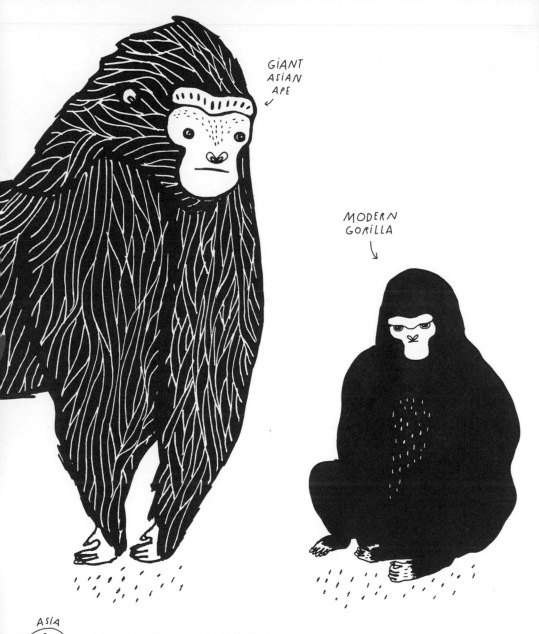

GIANT
ASIAN
APE

MODERN
GORILLA

ASIA
9
MILLION -
100,000
YEARS AGO

GIANT ASIAN APES

(GIGANTOPITHECUS)

ARE THE LARGEST KNOWN
APES OF ALL TIME.

THEY STOOD UP TO
10 FEET (3.5 METERS) TALL!

THEY HAD HUGE TEETH
AND LIKELY ATE
MOSTLY BAMBOO.

THE
MACRAUCHENIA
LOOKED KIND
OF LIKE A MODERN CAMEL. ← WITHOUT
A HUMP!

THEIR
NAME MEANS
"LONG NECK."

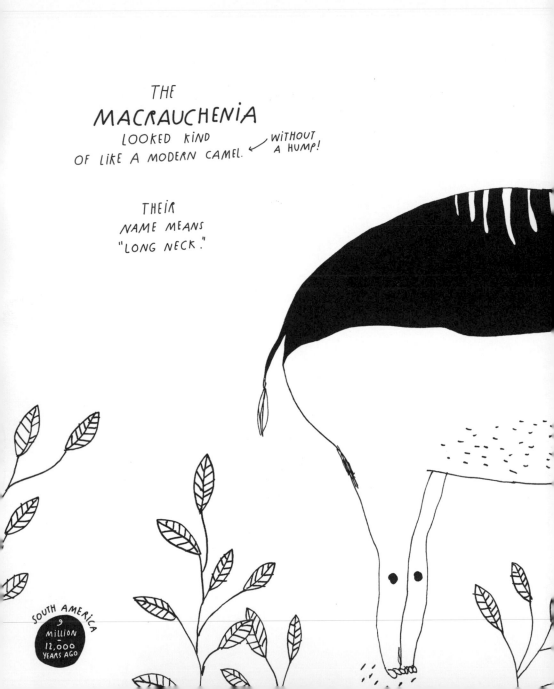

SOUTH AMERICA
9
MILLION
-
12,000
YEARS AGO

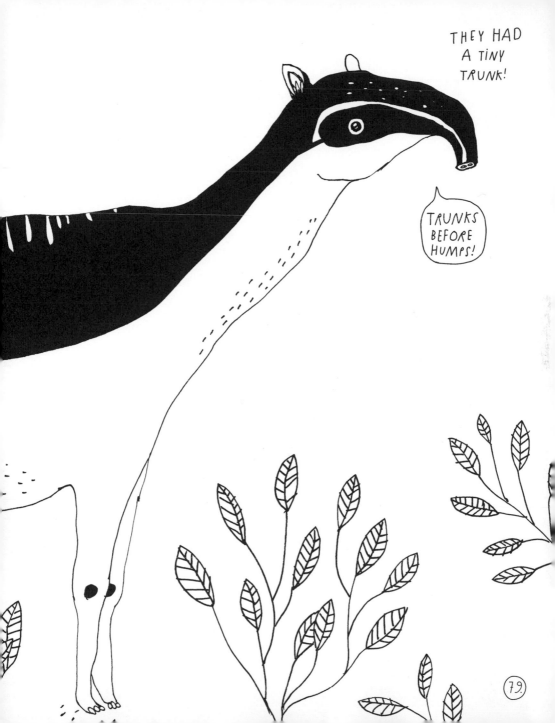

SHIVA'S BEAST
(SIVATHERIUM)
WAS AN ANCIENT
RELATIVE OF THE
GIRAFFE.

ROCK PAINTINGS
IN THE SAHARA,

LOOKING
KIND OF
LIKE THIS,

SUGGEST THAT
IT INTERACTED
WITH EARLY
HUMANS.

INDIA &
AFRICA

7.2
MILLION -
126,000
YEARS AGO

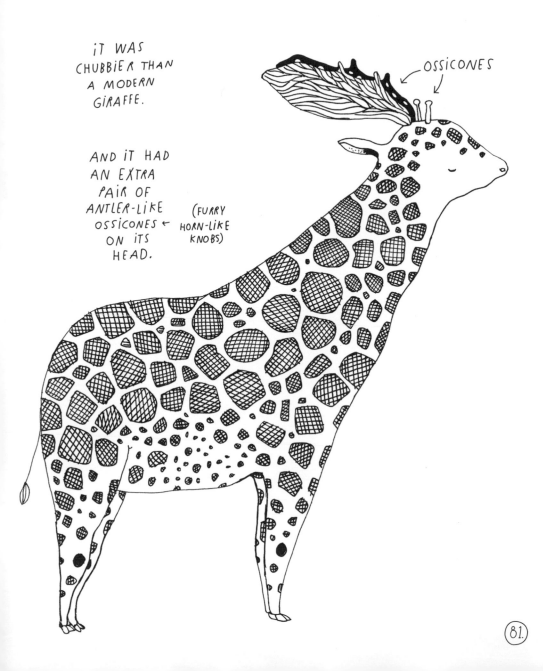

IT WAS
CHUBBIER THAN
A MODERN
GIRAFFE.

AND IT HAD
AN EXTRA
PAIR OF
ANTLER-LIKE
OSSICONES ←
ON ITS
HEAD.

(FURRY
HORN-LIKE
KNOBS)

OSSICONES

THE ONLY KNOWN
FOSSIL OF A MALE
WALRUS WHALE
(ODOBENOCETOPS)
HAS ASYMMETRICAL TUSKS,
ONE IS MUCH SHORTER
THAN THE OTHER!

IT LOOKED LIKE A
CROSS BETWEEN A
WHALE AND A WALRUS.

SOUTH AMERICA
5-3
MILLION
YEARS AGO

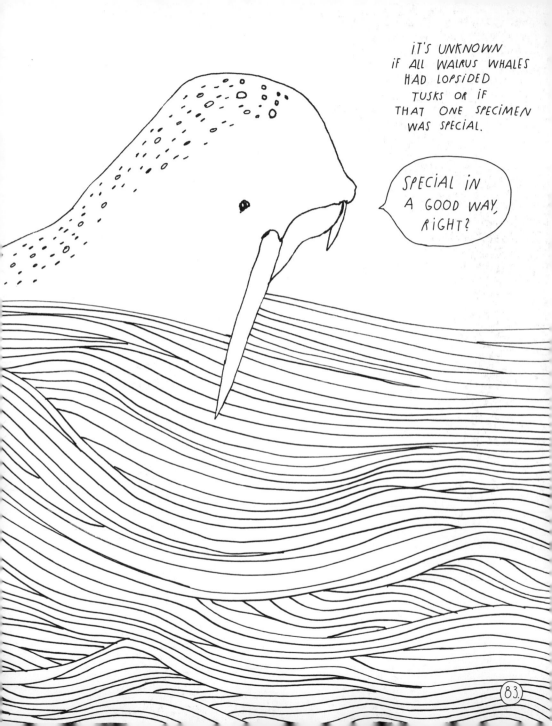

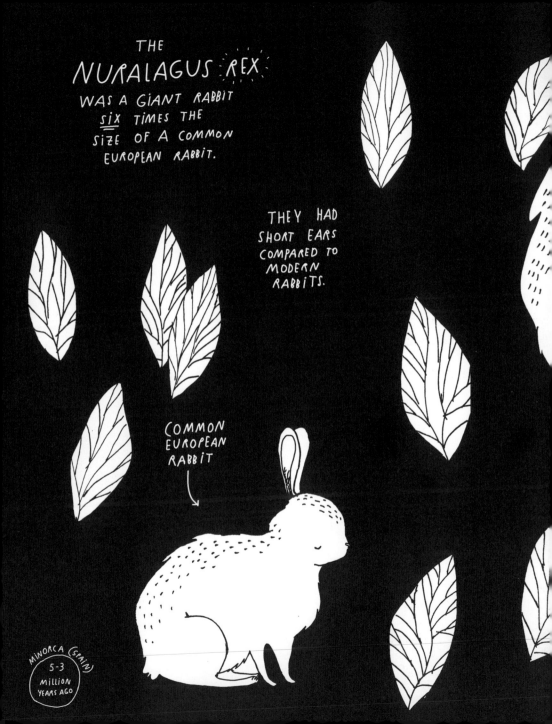

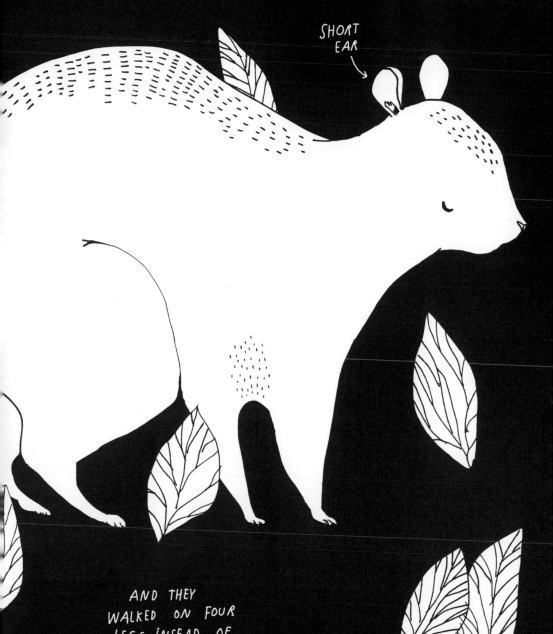

SHORT
EAR

AND THEY
WALKED ON FOUR
LEGS INSTEAD OF
HOPPING.

85.

GIANT PACARANAS
(JOSEPHOARTIGASIA MONESI)
WERE RODENTS THE SIZE OF COWS!

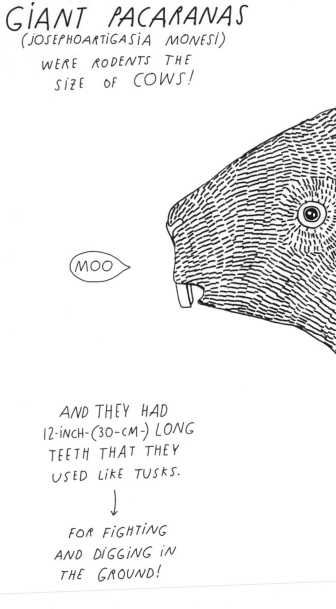

MOO

AND THEY HAD
12·INCH·(30·CM·) LONG
TEETH THAT THEY
USED LIKE TUSKS.

↓

FOR FIGHTING
AND DIGGING IN
THE GROUND!

URUGUAY

4-2
MILLION
YEARS AGO

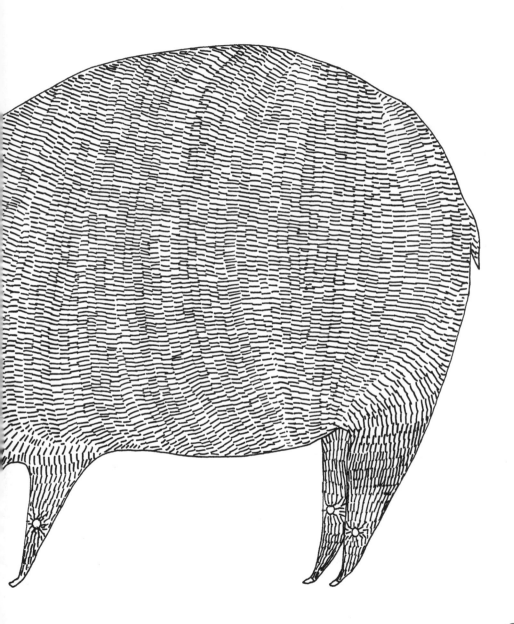

THE
iRiSH ELK
(MEGALOCEROS GiGANTEUS)

WAS ACTUALLY A DEER
WITH HUGE ANTLERS.

THEY SPANNED UP TO
13 FEET (4 METERS) WIDE!

EUROPE, ASIA
3
MILLION–
8,000
YEARS AGO

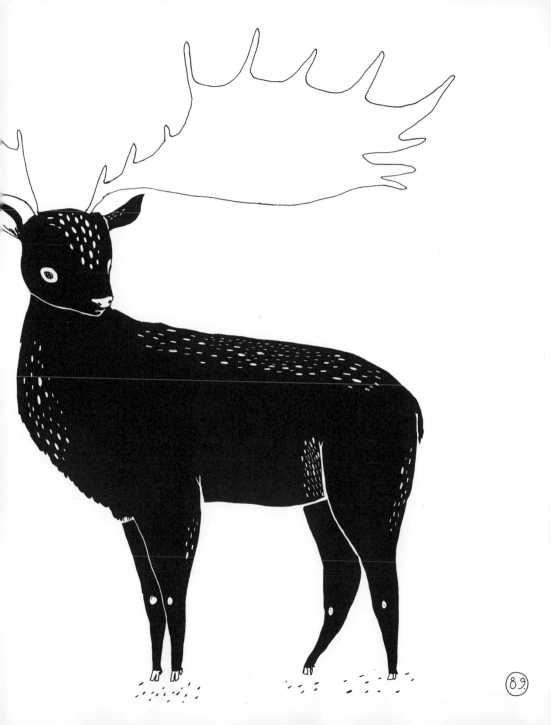

89.

GIANT SIBERIAN UNICORN
(ELASMOTHERIUM)
WAS A RHINO WITH A 6.5-FOOT-(2-METER-) LONG HORN!

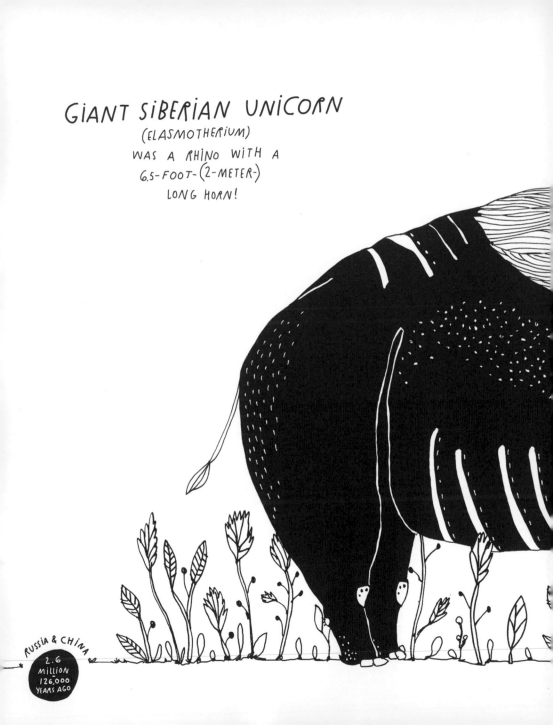

RUSSIA & CHINA

2.6 MILLION – 126,000 YEARS AGO

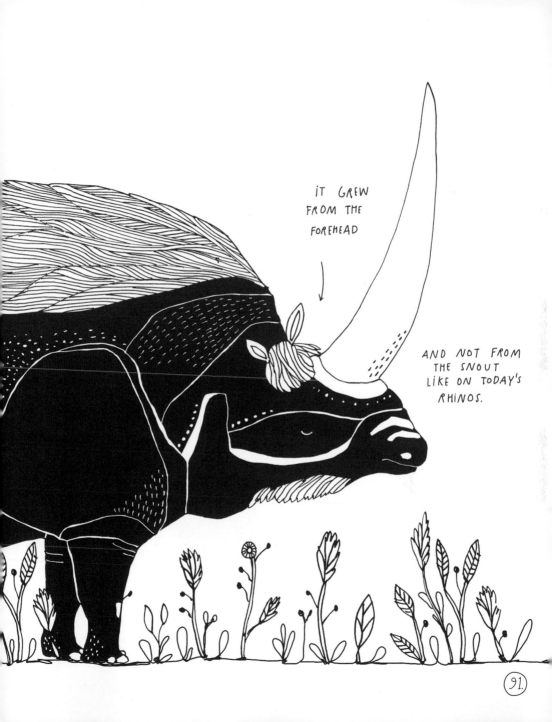

IT GREW
FROM THE
FOREHEAD

AND NOT FROM
THE SNOUT
LIKE ON TODAY'S
RHINOS.

WOOLLY MAMMOTHS

(MAMMUTHUS PRIMIGENIUS)

COEXISTED WITH
EARLY HUMANS.

THEY WERE
SIMILAR TO, BUT
A BIT BIGGER
THAN, ELEPHANTS
OF TODAY.

AND
HAD MUCH
MORE HAIR. →

EUROPE, ASIA,
NORTH AMERICA

2.6
MILLION -
10,000
YEARS AGO

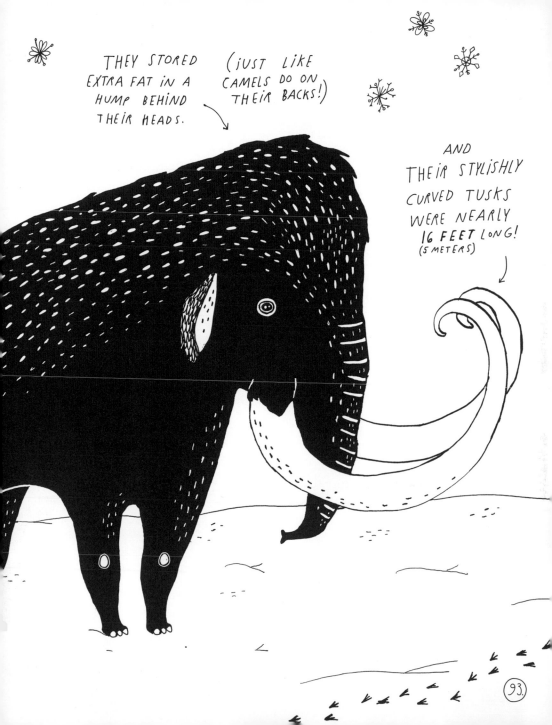

THEY STORED EXTRA FAT IN A HUMP BEHIND THEIR HEADS.

(JUST LIKE CAMELS DO ON THEIR BACKS!)

AND THEIR STYLISHLY CURVED TUSKS WERE NEARLY 16 FEET LONG! (5 METERS)

93.

CAVE BEARS

(URSUS SPELAEUS)
WERE THE SIZE OF
MODERN POLAR BEARS
AND LIKED TO HANG
OUT IN CAVES
TOGETHER.

IN SWITZERLAND,
THE SKELETONS OF
30,000 CAVE BEARS
WERE FOUND
IN ONE
SINGLE CAVE!

EUROPE
2.6
MILLION -
24,000
YEARS AGO

THEY WERE
MOSTLY
VEGETARIAN.

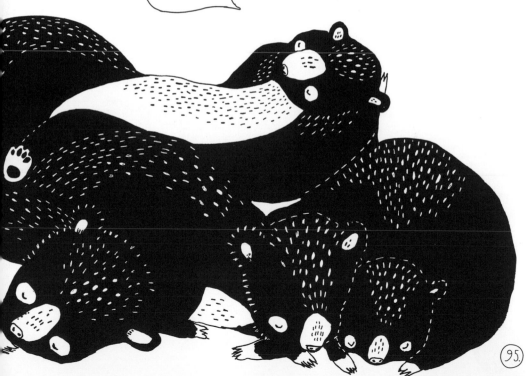

95.

THE

DOEDICURUS

WAS AN ARMADILLO-LIKE
ANIMAL THAT
WAS THE SIZE
OF A CAR!

IT HAD AN
INTIMIDATING
SPIKED TAIL.
↓

UNFORTUNATELY,
ITS POOR EYESIGHT MEANT
IT COULDN'T REALLY SEE
WHERE IT WAS MOVING
ITS TAIL
(SO IT WASN'T
VERY USEFUL).

SOUTH
AMERICA
2.5
MILLION-
11,000
YEARS AGO

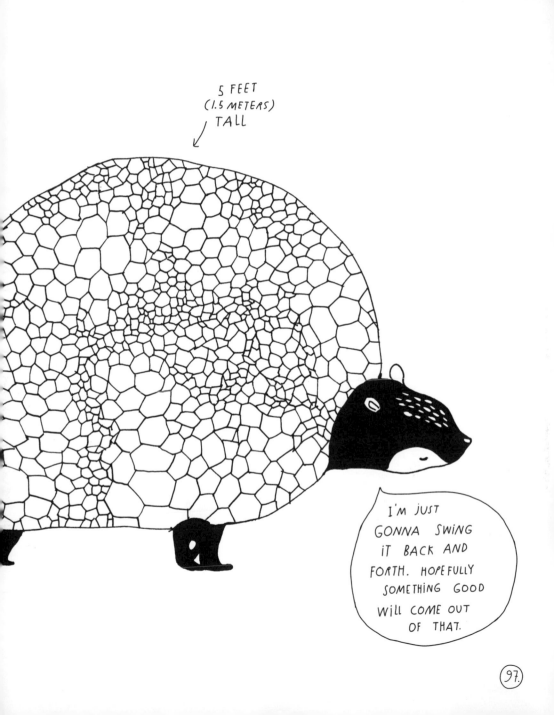

SABER-TOOTHED CATS
(SMILODON)

WERE CATS WITH 11-INCH-(30-CM-)
LONG CANINE TEETH!

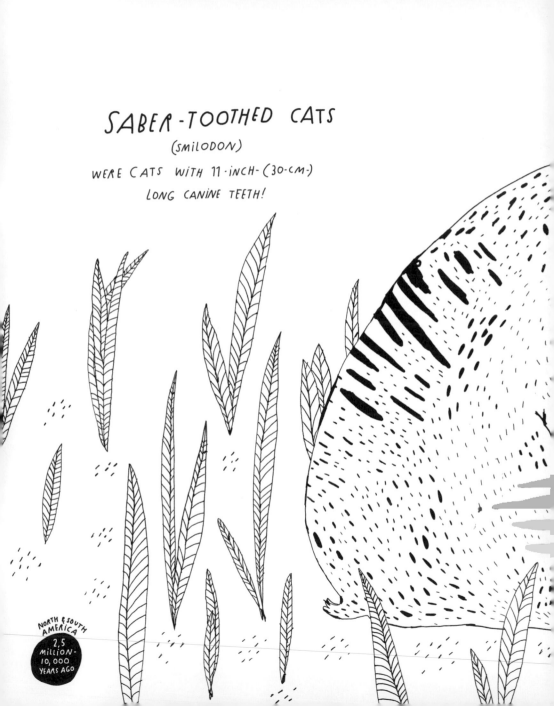

NORTH & SOUTH
AMERICA
2,5
MILLION-
10,000
YEARS AGO

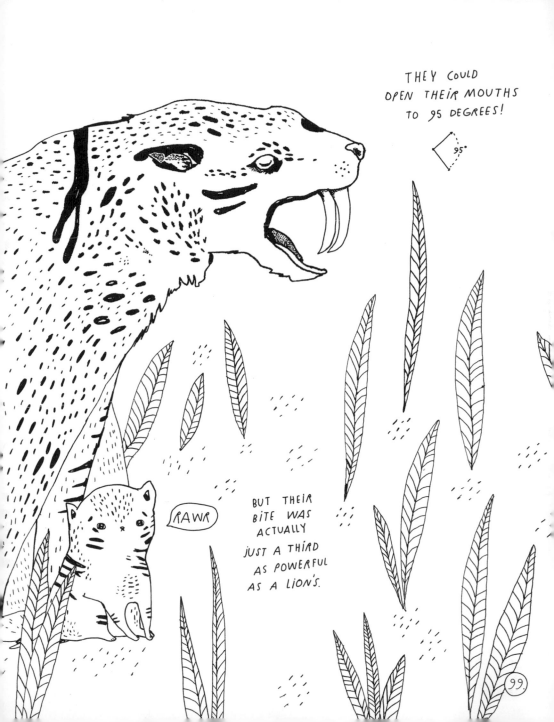

GIANT SWANS

(CYGNUS FALCONERI)
WERE OVER 6 FEET (1.8 METERS)
LONG FROM TAIL TO BEAK —
AND TALLER
THAN A PERSON!

THEIR SIZE AND
ANATOMY
SUGGEST THAT
THEY WERE
UNABLE TO FLY.

MODERN
SWAN

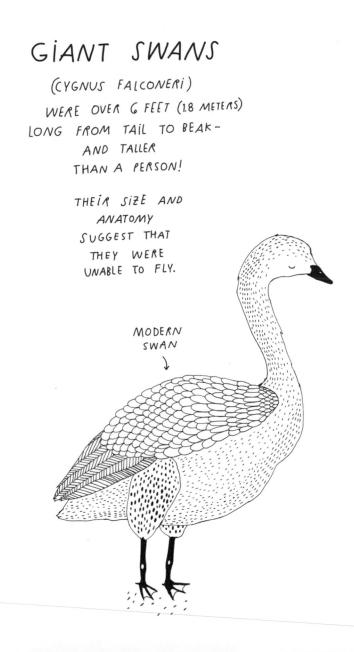

SICILY & MALTA

700,000
YEARS AGO

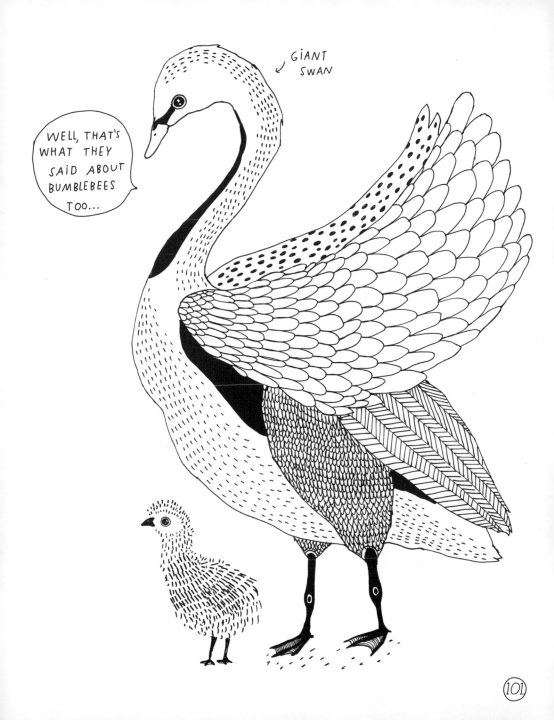

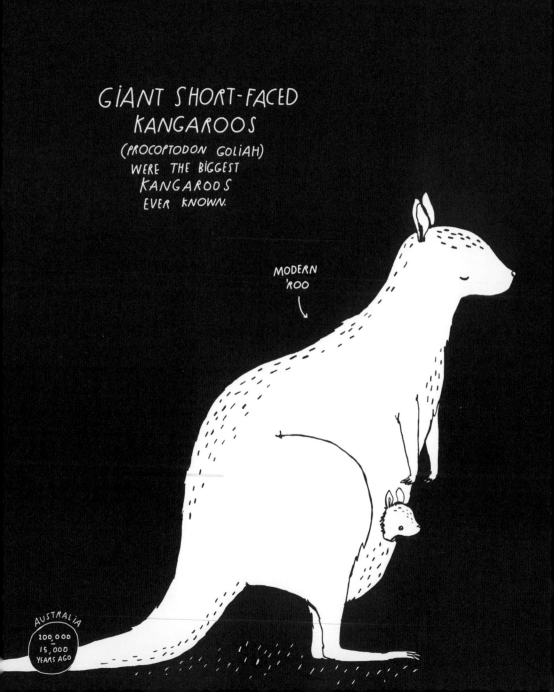

GIANT SHORT-FACED
KANGAROOS
(PROCOPTODON GOLIAH)
WERE THE BIGGEST
KANGAROOS
EVER KNOWN.

MODERN
'ROO

AUSTRALIA
200,000
—
15,000
YEARS AGO

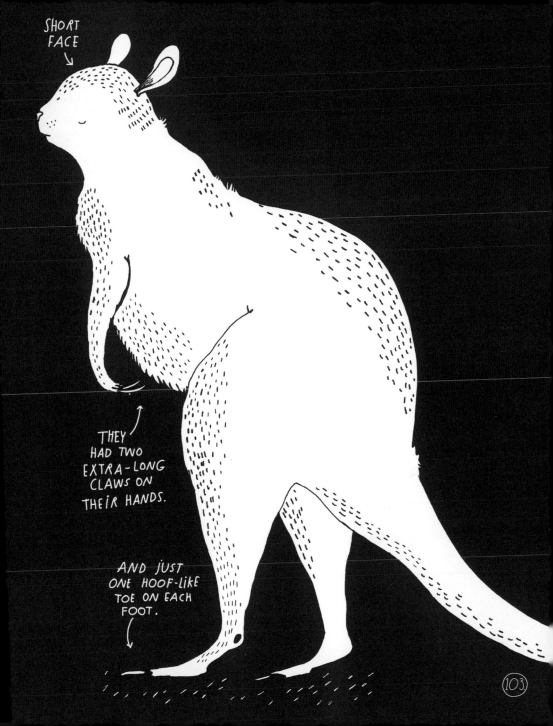

SHORT FACE

THEY HAD TWO EXTRA-LONG CLAWS ON THEIR HANDS.

AND JUST ONE HOOF-LIKE TOE ON EACH FOOT.

103

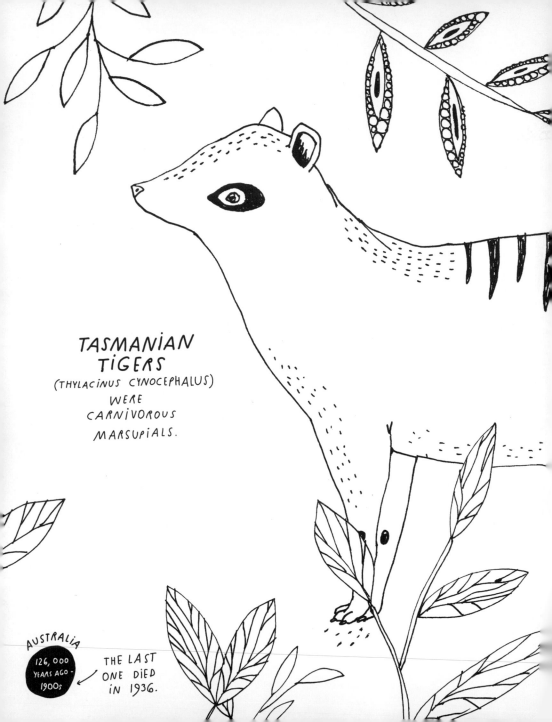

TASMANIAN
TIGERS
(THYLACINUS CYNOCEPHALUS)
WERE
CARNIVOROUS
MARSUPIALS.

AUSTRALIA

126,000
YEARS AGO -
1900s

THE LAST
ONE DIED
IN 1936.

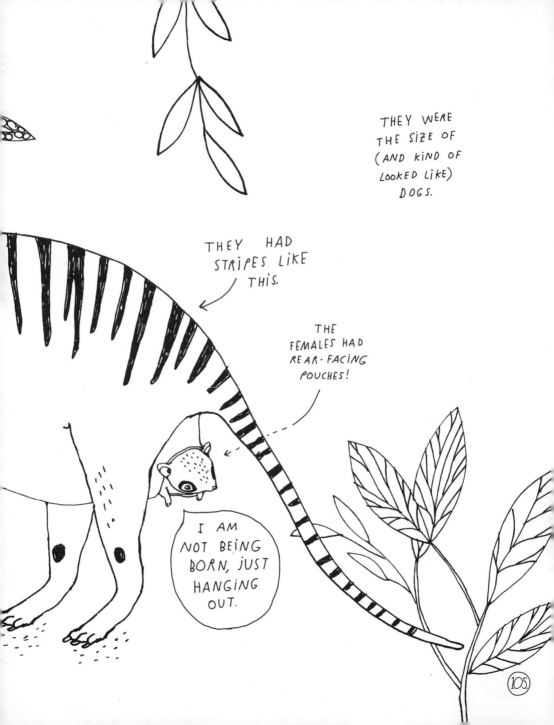

THEY WERE
THE SIZE OF
(AND KIND OF
LOOKED LIKE)
DOGS.

THEY HAD
STRIPES LIKE
THIS.

THE
FEMALES HAD
REAR-FACING
POUCHES!

I AM
NOT BEING
BORN, JUST
HANGING
OUT.

THE
DODO BIRDS
(RAPHUS CUCULLATUS)

WERE BIG RELATIVES OF PIGEONS.

3 FEET TALL!
(1 METER)

THEY WERE FLIGHTLESS
BUT HAD WINGS
THAT COULD BE USED
FOR BALANCE —
LIKE A
TIGHTROPE WALKER!

MAURITIUS

12,000
YEARS AGO
–
1662

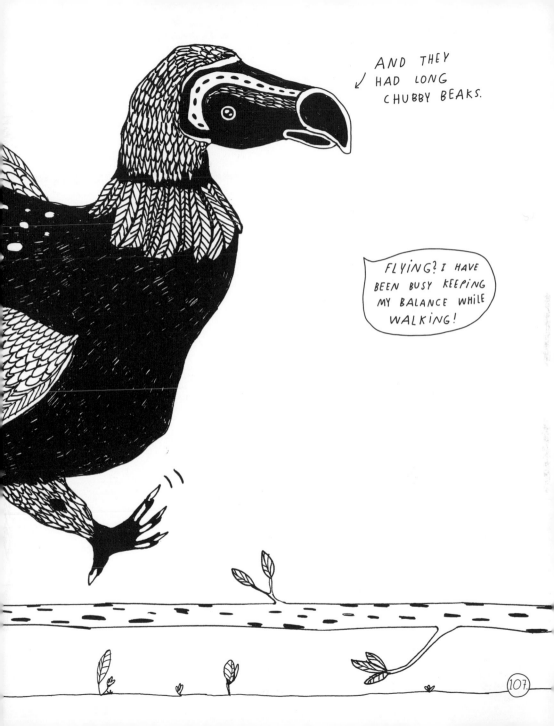

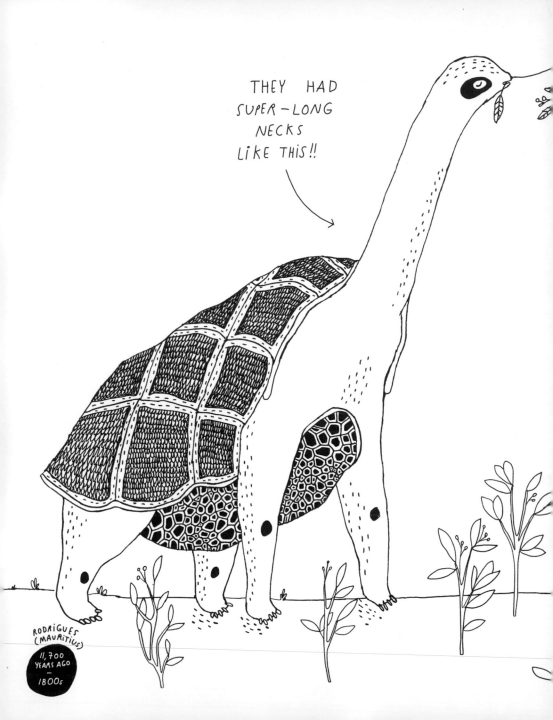

THEY
LIVED ON —— SADDLE-BACKED
RODRIGUES
AN ISLAND
NEAR GIANT
MADAGASCAR. TORTOISES
(CYLINDRASPIS VOSMAERI)

WERE FRIENDLY
ANIMALS THAT
LIKED TO HANG
OUT IN GROUPS.

MAJA
SÄFSTRÖM

MAJA
IS A STOCKHOLM-
BASED ARCHITECT
& ILLUSTRATOR
WHO HAS GAINED
INTERNATIONAL RECOGNITION
FOR HER QUIRKY
ANIMAL DRAWINGS.

FOR MORE
OF HER WORK,
VISIT:

WWW.MAJASBOK.COM

COPYRIGHT © 2017 BY MAJA SÄFSTRÖM

ALL RIGHTS RESERVED.
PUBLISHED IN THE UNITED STATES BY TEN SPEED PRESS,
AN IMPRINT OF THE CROWN PUBLISHING GROUP,
A DIVISION OF PENGUIN RANDOM HOUSE LLC, NEW YORK.
WWW.CROWNPUBLISHING.COM
WWW.TENSPEED.COM

TEN SPEED PRESS AND THE TEN SPEED PRESS COLOPHON
ARE REGISTERED TRADEMARKS OF PENGUIN RANDOM HOUSE LLC.

LIBRARY OF CONGRESS CATALOGING-IN-PUBLICATION DATA
IS ON FILE WITH THE PUBLISHER.

HARDCOVER ISBN: 978-0-39957-852-6
EBOOK ISBN: 978-0-39957-853-3

PRINTED IN CHINA

DESIGN BY EMMA CAMPION

10 9 8 7 6 5 4 3 2

FIRST EDITION